INTRODUCTIONS TO SCALE MODELLING
Copyright © 2023 by Tam Kinnear-Swift

Dedications

This Book Is Dedicated To:

Aunt Evelyn - Who bought me the book who started it all.

Dad - Who helped and encouraged me as a child.

Duncan - Just for being the man I always hoped you would be

JessyPants - Where would I be without you? You lift me up more than you ever know.

John Alec Richie - A constant inspiration and friend.

Johan - Mr Flappy bits himself, whose humour and knowledge is irreplaceable

Squiddy - For saving me when I was at my lowest, giving me a reason to live everyday, all the unconditional love, memories and fur everywhere.

Dee Kirk - Who encouraged me to write.

All of my followers on YouTube - Who have always helped and supported everything I've done.

And lastly, my ex wife, Anita - Who made me realise how to be better.

Table of contents

Chapter 1

Starting out - Tools you should consider buying.

F irst of all, I thought it would be appropriate to go through some of the essential basics for modelling. I am of course, acutely aware that modelling can be an expensive hobby, and a lot of the bits I have accumulated, I have done so over the years as opposed to all at once, so, I thought I would give some helpful tips and hints as to what you should consider as to be priority for a starter modeller, as well as a few helpful extras that make things just a little bit easier, at prices that wont break the bank.

This guide has been put together, with the thought that the modeller has not much space into which to pack his stuff away, as opposed to the modeller who has a designated room/building for his hobby. It has also been designed for the modeller on a budget, as opposed to one who has moderate/infinite means at his disposal.

This guide, is also pretty generic. it covers pretty much all types of modelling, so if you have a set genre in mind, then please don't take this as read that this will be what you need.

Tailoring a modelling kit to what YOU need in genre specific modelling will be your best bet, but this should be a good starting point for those who prefer, as I do, a broad spectrum of modelling.

The Tool Box

Never underestimate the importance of a toolbox, especially if you live with a 'neat freak'. Needless to say, its brilliant for storing everything you need for modelling, from paintbrushes and paints, to the spares you inevitably collect throughout the years whilst modelling and everything in between. I would scour eBay for tool boxes as they more often than not have great deals on them.

A Variety Of Adhesives

A variety of adhesives are necessary throughout the world of modelling because the variety of kits available differ in the make up. For example, while you can get away with using polystyrene cement on an Airfix kit, it will be worse than useless on a resin kit as it will not bond. PVA glue is a good adhesive for detailing (for example, if you mix some sand coloured paint and sand with PVA glue, and apply it to the tracks of a tank, it makes for great weathering detail) and terrain modelling, but has almost no other uses outside of this. Spray adhesives are also quite handy for terrain modelling, but again, not much use for anything else outside of that. More about this in chapter 3.

Sandpaper Blocks

These are invaluable, for fine sanding, adding scratches and chips to paintwork etc. They are also relatively cheap, and usually come in a pack of 3 for a pound form various pound shops.

Sandpaper Blocks

"These are invaluable, for fine sanding, adding scratches and chips to paintwork etc. They are also relatively cheap, and usually come in a pack of 3 for a pound form various pound shops."

Brushes

A wide variety of shapes and sizes is a good idea, big wide brushes, for less detailed work as well as smaller for fine detail. Italeri do a great fine detail pack from 3 to 000 and its relatively cheap, around about £4-5. This does not impinge on the quality as they are a great set, and i personally own one. Alternatively, Games Workshop do some great sets, but they're quite pricy.

But you can also get some great cheap sets from craft/hobby shops and pound shops. I use Kolinsky sable hair brushes, mostly from AK Interactive for my fine painting, and synthetics by Royal and Langnickel for broader work.

Files/Sanding sticks

A good quality set of metal files is a MUST. Although sprue cutters (see below) will minimise the risk of cast marks being left on your kit, you will inevitable find you will need these for a variety of different tasks, mostly i find, its for filing off miscasts on the kits and detail work. I recommend getting a set with 5 or 6 different shapes (flat, rounded, triangular etc) in a set. These are relatively cheap and can be bought from pound shops and the like.

Sanding sticks are cheap and come in either model specific brands, or generic brands mostly used for nails and such, but are just as good for modelling as they are for anything else, and they're cheap, like the budgie. These are available in many different grades from coarse to super fine.

Sprue Cutters

These are quite an important bit of kit. They will help you trim your kit from the sprues with the minimum of fuss and effort, and minimise the risk of damage to the kit whilst doing so.

Masking Tape

Invaluable for many uses, particularly masking off areas whilst painting, applying to wet paint and peeling off, giving a chipped, weathered effect, or applying to tools to add a non-slip surface for handling. Can be bought in mufti packs from most pound shops or hardware shops.

Hacksaw and spare blades

Ideal for modelling, due to its size. Useful for resin modelling, as more often than not, the cast marks are still on the kits when they arrive and need to be cut off before assembly, but it is slow and hard work. A Dremmel (see below in extra's) is better for this particular task. Found in most pound shops or hardware stores.

Craft Knife and blades

Craft knives are essential if you are planning on scratch building or modifications. Not only that, they are handy for adding scratches to paintwork and fine weathering detail as well as the more obvious uses of cutting/scoring etc. You can get cheap sets from the pound shops etc, but i would invest in a decent craft knife first, as the ones from the pound shops tend to be plastic inside and snap under even the least amount of pressure, however, this being said, these cheap sets from pound shops do come with a multitude of blades and for this reason alone, it is worth investing in a set.

A good quality craft knife will cost between £8 and £14 depending on the make and where you get it from, but it is well worth it as it will more than likely last you a lifetime. If your a newbie to modelling, i would recommend the Citadel from Games Workshop Craft Knife, as it has a non-slip rubber handle. This is particularly suitable for younger modellers, although i would recommend parental supervision during this process.

Paints, and lots of them!

Paint is the one thing you will always need as a modeller. There are several different types and makes on the market, all designed for specific uses. I personally only use acrylics/hybrid acrylics, but you will need a tailored set of colours at some point. This was the case when i started my Tiger tank, the games workshop colours are fairly generic and will do in most cases, but for world war two German models, you will need a fairly specific set of colours.

AV Valejo paints do specific colours for specific nations, are very good quality paints and accurate in their colour. My only complaint would be that they need priming first and have a tendency to need 3 or more coats and will quite easily rub off with minimal of contact, so a matt varnish or setting agent will be needed to prevent this.

Tamiya and Mr. Color are my absolute favourite paints to airbrush with, although there are many great paints on the market, such as MRP, AK interactive 3RD gen, Mission Models, Outlaw paints, Humbrol and many more, its really a case of finding a paint or paints you like.

Enamel paints, take a bit more skill to use. Humbrol do a fairly comprehensive range, but for a starter modeler, I would avoid these until you have honed your painting skills a bit, as working with enamels tends to be a fairly messy affair and the brushes need cleaning with white spirits. I have been modelling since I was 8 and still struggle with enamels, so be wary when attempting to use them, as they have very little room for error.

Metallics are very handy paints to have also, they are ideal for many purposes such as undercarriage of aircraft, engines, exhausts etc. and dry-brushing over black/gray to producing gun-metal effects. They are ideal for mixing with darker paints (I.E. Black or Brown) for weathered looks on vehicles/aircraft etc.

Washes

Washes are an invaluable aid to weathering for modellers. They are essentially a very very watered down variant of the paint, and are used to lowlight and weather models and pick out details, such as panel lines and rivets.. Enamel washes are most popular, because they can be reactivated a re worked as many times as you like, unlike acrylic washes, but Vallejo do a great line of acrylic washes

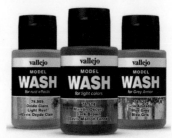

The following bits and pieces are additional extras which, although useful, are not necessary to modelling, although, they do make things a *LOT* easier!

Eye Shadow

You what now? Eye Shadow!... Yes... really... Eye shadow is a modeller with a budgets best friend. It is brilliant for weathering and fading and a hell of a lot cheaper than pigments. In my opinion, its better than pigments too, whilst not designed *SPECIFICALLY* for models, it is designed for a surface that is a hell of a lot harder to stick to... skin. *AND* it comes in a multitude of colours and shades. Something which modelling pigments, all too often don't. Its cheap too. **Beware!** Some eyeliner sets come with glitter in them, whilst this is good for exhausts etc, its *NOT* good in general (I found this out the hard way!) so is something to watch out for if buying a set. Oh, did i mention it was cheap too?!

Rotary tool and attachments

This is an extension of the hacksaw, and makes modelling with resin a hell of a lot easier, but doesn't half make a mess! It is strongly advised that you wear a mask when using this, as it *WILL* kick up a lot of small dust, which is very *VERY* bad for you if inhaled. A mask is highly recommended for this task. It Comes with a multitude of useful attachments including sandpaper, micro drill bits, sanding stones, cutting discs, wire wool and other bits very handy for modelling with.

"It WILL kick up a lot of small dust, which is very VERY bad for you if inhaled. A mask is highly recommended for this task."

Clips/Clothes Pegs

I was in two minds about whether these were essential or optional, I will leave that to you to decide, but i have put these in optional purely because I tend not to use them so much, you on the other hand, might decide the opposite. the clip shown is fairly cheap and comes in a set of six. I cant remember exactly, but I they were about 4 quid for a bag of six. Clothes pegs make a very cheap alternative, but often don't have the same span and aren't very good for larger scale modelling.

This list is by NO means exhaustive or complete, it is a good guide for the beginner, and will serve you well in the early days. You will, no doubt, pick bits and pieces up as you go along, and develop your own list of kit through trial and error, but this should provide you with a basis for modeling on a small budget.

Chapter 2

The Importance Of The Research Phase And The Build Plan.

I f you're an old sweat when it comes to modelling, this article is more than likely to be teaching you to suck eggs, and you are probably unlikely to find anything new or helpful within it.

However, if you are new or relatively new, you are likely still to be in the development stage of honing your skills and techniques, then this article, with a bit of luck, will impart the importance of the research and planning phase of your builds.

Of course, modelling is subjective art for everyone, if, like me, you are aiming to create an accurate, scale copy of a given subject, then this is a vital skill to help you achieve this. If you are happy to build out of the box (OOB for future reference) then this will not be such a vital element of your model building, However, this does not mean you will not need it.

I can only speak for myself when I impart some of the processes I use in researching subject matter, as I pointed out before, while tips and hints are relatively easy to come by on the internet, the actual build process is individual to the modeller, where one person may build the entire model before painting it, others may paint it as they go and then assemble, and touch up and add weathering and decals as required. As a modeller, you will probably develop your own style without realising you are doing so, simply by what feels right for you, or, as most do, what feels the easiest route to the achieve the end goal.

A lot of modellers tend to have a stash, or a grey army around the house. usually of kits they have seen when out and about or at modelling fairs, exhibitions etc. and bought with the intent of building. This can be useful, as personally, sometimes, I just feel the need to paint, whether it is to relax, or just simply because I've not painted for a while. A lot of my modelling friends have stashes that number in the hundreds, I personally, prefer only to have a stash of no more than ten to twelve kits at a time, as I find this distracts me from current projects (a disorder known comically within the modelling community as ADMD – attention deficit modelling disorder. *HOWEVER*..The best laid plans of mice and men... My stash is currently at over 120.

I tend to have a stash of differing models, as I can never predict what I will feel like building at any one given moment, but, each and every one of my kits in my stash, has a build plan already done for it and/or research done before I even think about starting it.

Step 1: Choosing your kit.

A lot of the time, the kits I buy are kits I've seen whilst i have been mooching around a model shop, or browsing eBay, and i would tend to think that this is probably the norm for most modellers. I do tend to buy most of my kits from eBay though, for two reasons. 1. Its a lot cheaper 2. It allows a period of time before the model even arrives to research and plan the build. Very rarely will I have a "I know what I fancy building..." moment and actively search for a specific kit/figure, so this is a very personal thing to the modeller.

Step 2: Research

I cannot understate the importance of this if you are planning a detailed, accurate kit. For the benefit of this article, we will assume the model we have bought and are planning to build is Airfix's 1/24th MKIVA P51k Mustang.

When you purchase a kit, often before you've even got the kit home, you will have an idea in your own mind what you want to do with it. I ALWAYS without fail, sit and browse the internet, sometimes for as much as 30-40 hours finding what information I can about the original model that is being depicted. If I cannot find the exact model, I will try to find a picture of a similar one.

"What does the Gunsight look like? What colour are the camouflage markings? What does the cockpit look like? what colour is it painted? do I already have this colour or will I need to buy it? Can I mix a colour similar enough to it with the colours I already have? Questions that can only be answered with the proper research and time put in in the first instance."

Whilst searching the internet (I can't even remember how modellers coped before it) I always make a folder, marked with the name of the model, and the scale, and I save any reference pictures I find that will be helpful. These can range from camouflage markings, to close up pictures of engines, cockpits, instrument panels etc. *ANYTHING* you can find that will help with the accuracy of the model is worth looking at and saving for future reference.

Sometimes though, you will have no idea what you want to do with it *UNTIL* you start researching it. More often than not, this is the time when ideas develop. I have bought a kit before with a clear idea in mind when buying it, and upon researching it, have found something that made me sit up and say *"WOW – THATS SEXY! I'M GUNNA DO THAT!"*

More often than that though, you will probably find yourself conflicted between several different paint schemes/decaling options and its just a case of thinking what you want to do or what would be the most effective to achieve with minimal effort.

If you are converting a kit, as i did with the Spitfire MK Ia Conversion to MK Vb, then you may find it helpful to find a schematic, or a blue print to look at the differences between the types. As an example, I had to cut the cannon ejection ports on the under wings on the Spitfire, as the MK Ia wasn't fitted with cannons, and I also had to shape the wing blisters for the same reason. Conversion is a difficult, but ultimately rewarding job, but if you don't do your research properly, you may as well just build the kit OOB.

Step 3: The build plan

Again, something which I find absolutely essential to a build, is a clear idea of what you want to do with it once you start. It is a bit pointless starting a kit, only to um and ah as to which of the three versions supplied in the kit you wish to build. This is where the research and the build plan often spill over into each other. Once you have your kit, and you have looked at which version you are going to build, will you be adding after market products such as decals, extra detailing like seat belts? (Airfix are notorious for leaving these out on their 24th scale aircraft and as such, I always end up buying them) Will you be using a standard paint scheme, or something a little less standard? Is it going to be wheels up, or wheels down? Pilot or no pilot?

I find it easiest to write these ideas down, in scrap form first, then to clarify them by looking at the instructions and write down when and at what point you are going to add any extra details during the build. After all, its no use buying a set of seatbelts, if you then whizz through the kit, and realise you have forgotten to put them in (you may laugh, but I have actually done this more than once before) If you have a printer, or access to one, print out some of the pictures you have saved and pin them in the appropriate places to the written build plan, so you can see what you are doing at any one given point during the build. For example, a picture of the cockpit beside the written plan and instructions is going to help you more than having to constantly look away from your build and find the appropriate picture on your PC.

I made the mistake, in my first few builds using a build plan, of putting a time scale on each part of the build. It is entirely up to you whether you do this or not, just be aware that things, more often than not will not run to a time scale, and ultimately, this just may be wasting your time by trying to plan this bit meticulously.

Step 4: The execution

The golden rule of build plans is, once you have a plan you are happy with, **STICK TO IT**! There is no point spending all this time, getting your thoughts organised and ready to go if you flit backwards and forwards between sections that have no natural connection to each other.

The easiest way to plan a build is through a natural progression. It is entirely pointless if you start with painting the canopy, then stick the wings together, then build the engine, then paint the instrument panel etc.

Remember also, there is no rush! modelling is not a timed hobby. And although there will undoubtedly be points where you scream **"OMG!"** and start grasping your hair, the ultimate goal is not to produce the best model in the world, or the most accurate, or the best painted, but to *ENJOY IT* and have fun and hopefully, to develop your skill so as it leads to further enjoyment.

Step 5: The conclusion

I often find, in order to fine tune future builds, it it easier to write down my thoughts on the build as I go along. This Blog gives me a platform to do so, and also add pictures so I can see how the build is progressing, and analyse how I have done so far, what went wrong, how I can improve for the next build and also, how good the kit was, and whether it is worth buying a kit form the same manufacturer again. Most online blogs are free, this one certainly was, and I thoroughly recommend blogging your builds as a way of not only assessing them, but also recording you progress and advancement as a modeller.

> "It is equally important though, to record you thoughts and impressions of how you felt the build went as a conclusion. This will not only help you to appraise what you feel perhaps you did well, but equally important, will help you appraise what you think you could do better or where you went wrong. This will help you better understand your own strengths and weaknesses as a modeller. We ALL have them no matter how long we have been doing it."

Remember, there is no such thing as a bad build, because every time you build a kit, you will learn something new, or find a new strength or weakness you can either improve on or develop. I have had builds where the finished item was really shoddy, the paint work was awful, there was glue fingerprints all over the kit etc, but at the end there has always been something that has made me say *"hey! the weathering on that is really realistic!"* or *"I really improved on my decaling technique on that build"*.

Reading back through this article, I can see how rigid and meticulous this must seem. Remember, this is a guideline only, as every modeller works differently. Hopefully there will be a few things in here you will be able to find useful, and adapt to the way you work whilst enjoying the hobby, as I did when I was hunting for tips and techniques to help me develop.

Chapter 3

Different glues, and their uses

I n this stage, I'm going to take you through the different types of The most common plastic used to manufacture model kits include polystyrene and ABS, because of this, without a doubt, the best glue for gluing a model kit together with is polystyrene cement or poly cement. Poly cement is a solvent based cement suitable for plastic model kits.

The cement works by melting the plastic on application and welding the two glued pieces of plastic together to form a strong bond. As you can see, there are many different makers. Revel, humbrol, Tamiya and many more. But what we're looking at today is not manufacturers, As essentially, the glue is all the same, but the ease of use and application.

Tubes are the basic form of container. This requires a little extra help if you want accuracy in the form of a kebab stick, a cocktail stick or some other applicator, Otherwise, results will likely be inaccurate and messy if applied straight from the tube. For that reason, I don't use them unless it's absolutely necessary. For example, if I'm out of every other type of glue.

Then there are these applicators, which you just unscrew and apply through the length of that. As you can see, these are a lot easier and a lot more precise than the tubes, but still not pinpoint accurate. I've tried these, but I'm not overly enamoured with it, because it takes a lot of getting used to to get the pressure right and the amount out. So for that reason, I don't use it.

And then we have the types in bottles. These are my go-to glues, not because of the make or the brand, but because they have brushes. You literally just brush the glue on. This is the normal type of cement. They are much easier to use than any other type of applicator I found, Unless you want to be messing about with a kebab stick or a toothpick, which is OK if that's what you want to do, But I just find it easier to apply with a brush.

Superglue is mostly used in model making for applying photo etch. photo Etch is the metal laser cut parts that are made in much greater detail than the plastic moulded kits can produce. These usually are bought separately but can sometimes be included in the kits.

They're also used for resin parts such as wheels, wheel bays, cockpit upgrade sets, which again are usually bought separately but sometimes are included in the kits, so it's a good idea to have some super glue, an idea of how it works, and how quickly it sets ETC, In case these parts come with your kit.

The next useful glue is PVA glue. This is the white glue that you use at school. This is used for a myriad of different uses, but mostly for holding on pieces temporarily or permanently. For example, the canopy whilst airbrushing or whilst gluing into place.

It can also be used to mask off the canopy before airbrushing. It's pliable, dries clear, and so is a very handy glue to use on clear parts. So whilst it's not essential, it's a very handy glue to have during your model build.

"It's a good idea to have some superglue, an idea of how it works, and how quickly it sets ETC, In case these parts come with your kit."

If you are intending to build terrain or dioramas, you may want think about investing in a hot glue gun. whilst not essential, this is a very handy addition to any modellers toolbox.

It works by heating and melting glue, which when applied to a surface, will cool and hold it together.

You will find that PVA glue will likely do the same job that hot glue will, but hot glue has the advantage of drying a lot quicker.

"And, as the tabletop Wargamers out there will tell you, you can mix it with red paint for blood effects or radioactive ooze, or let it dry naturally for spittle effects for monsters mouths and the likes.."

UHU is a solvent based glue that is similar to hot glue, but obviously, not hot.

It will do that same things, IE, it will hold scenery and terrain down without having to worry about it drying white, like superglue does. Again, whilst not essential, it is another great glue to have in your toolbox, and, as the tabletop Wargamers out there will tell you, you can mix it with red paint for blood effects or radioactive ooze, or let it dry naturally for spittle effects for monsters mouths and the likes.

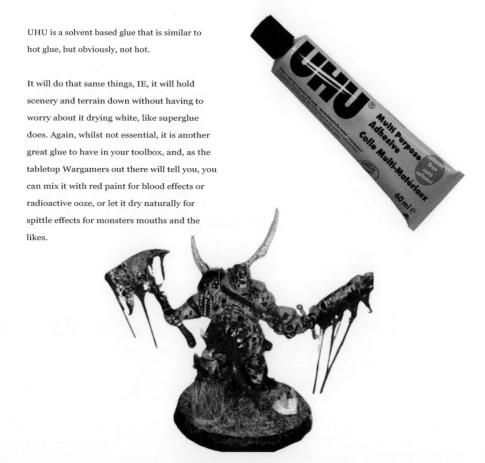

Chapter 4

Getting rid of
seam lines

T he objective of scale modeling, is to turn a collection of parts into one, accurate representation of the original subject.

For a young or inexperienced modeller, getting the kit glued together is enough of a task, so I wouldn't worry about the finer points just yet, unless you feel you are up to the task.

For the more experienced modellers, the idea is to accurately represent the subject in question. This means getting rid of the seam lines and joints where they are glued together. This will vary significantly with differing kits, for example, you may not want to get rid of all seam lines on an aircraft, because, sometimes they are accurate to the way the original aircraft was constructed and ergo, part of an accurate look, for example, a BF109 has a seam line running down the centre of the fuselage to the cockpit, so you don't want to be sanding and filling this.

Dealing with this is not complicated, it just takes a little careful work and a few supplies. You have both the mould lines left on the pieces from the injection molding process (sometimes called chaff or miscasts) as well as the gaps and lines where you join the pieces together. Mold lines are small ridges that run across the part, and usually just take some filling and sanding. The joints where pieces fit together, usually need more work and, usually involve putty or filler, or sometimes both.

Start using a craft knife/scalpel (I use a xacto handle with surgical scalpel blades) and scrape lightly along the line. This will take off high spots and casting residue, and sometimes, is all that is needed to get an even finish/matching seam lines. You can then tidy this up by going over it with Tamiya extra thin, or a similar type of cement

Next, we'll use the files to get the worst areas shaped, for example where two seam lines don't match or fit very well. Using a rough, flat file (or shaped if the contours demand it) file gently until the lines are roughly even.

Finally, we'll use sandpaper, starting with rough sandpaper and finishing with fine. Again, sand gently until the edges are roughly similar, and finish off by sanding gently until they match.

You should now have a seam that looks and feels level. Throughout the course of this hobby, you'll be using a lot of sandpaper, and you can usually find cheap, good quality sandpaper in pound shops. Personally, I prefer sanding sticks, again bought, in a differing number of grades, rough, medium and fine etc from pound shops/Amazon.

After this initial work with the sandpaper, take a good look at your model under a bright light and a magnifying glass if you have one. You will usually be able to see gaps at this point. This is what the filler/putty is for. Different modelers swear by different brands, the two I use are Milliput epoxy putty and Vallejo filler, both readily available in model shops and even in hardware shops. Have a look around on various model sites and forums, and you'll find people who use other products like gap filling superglue – Modelling is very much a hobby where everyone will have their favorite, and only trial and error will find out which you prefer.

To apply filler, hold your filler tube by the bottom and squeeze gently and wipe it along the seam, making sure you get it pushed into the cracks. leave a few minutes and repeat if necessary. Smooth it a little by then wetting a cotton bud and going back over it. Using a wet cloth, wipe off any areas where it is not needed, and for more stubborn areas, give it a light rub with fine sandpaper. Filler, will usually dry enough to be sanded in earnest in about 45 mins, unless its Vallejo filler, you'll need to leave that a lot longer.

> "Modelling is very much a hobby where everyone will have their favorite, and only trial and error will find out which you prefer."

If using epoxy, two part putty, mix as per instructions, apply with a wet finger and leave at least 3 hours to dry before sanding. The advantages of this, is that it will dry harder than filler, and is therefore easier to sand/shape/sculpt.

Once the filler/putty is dry, use sandpaper and/or files to smooth the surface so that it matches any details on the kit, yet hides the seam lines or cast marks. It's better to take your time with this step and remove too little putty and plastic at one time than too much and have to repeat the process, something I learned the hard way. After each session with the sandpaper, put on a coat of primer over the area you're working on. I just use a black acrylic, as nine times out of ten, I use the Vallejo filler, which is white, so a grey primer wont really show up any differences, but its up to you what you use in this step. This will allow you to see any areas needing more sanding and filling. Repeat this process until a coat of primer shows no evidence of the seam line, and you're done.

If the files/craft knives etc get covered with putty or filler, just rub them sideways on a course grade sanding block, this will in most instances, remove all the gunk.

Chapter 5

Thinning Paint For Brushes and Airbrushes

I f you look back at some of your first models, I bet that one of the first things you notice is how thick the paint is. I know it was definitely mine "thin your paint" is also one of the most commonly suggested tips when people ask for feedback on Facebook forums and the like.

But how thin is thin enough? In this chapter we look at how to thin paints properly for both brush painting and airbrushing.

There are several reasons why you should thin your paint down before using them, especially if you intend to use the Humbrol paint from the Airfix starter kits, so lets have a look at some of them.

Undiluted paint is often too thick. It can not only cover and obscure the details you wanted to keep, but also lead to cracks once it is dried. Depending on your undercoat/primer it might require several coats of paint before the coverage is good enough and the colour has the colour you intended. If you apply one thick coat, it will look ugly and obscure details. Overall, too thick or just completely undiluted paint can ruin your model. In the worst case, you may have to strip it and re-do it all over again.

Whilst thinning your paint down to the consistency of skimmed milk may give you a starting point, it might not work for every colour. But... as a rule of thumb, this will work for airbrushing, as this is correct for atomisation in the cup, but it may not work for certain colours for brush painting.

How much thinning down is needed depends on the color itself, how well it covers on the primer, and how thick it is in general. The same colour from the same range can have different consistency depending on age and how much air has been let in the pot (how dry the paint is). Different ranges also have very different measures of how thick or thin it is straight from the pot.

Colours like red, orange, yellow are often thinner and do not cover as well as others. But what might surprise you is that white paint actually contains lots of pigments. Thus it is often quite thick and dries quickly. Thinning down of white paint is definitely needed.

Acrylic paint gets semi-translucent when it is thinned down nicely (one of the major benefits of acrylic paint). When you apply the first coat of paint, you should have rather less paint on your brush to avoid flooding the surface. The paint should neither pool nor run, because if that is the case, it is too thin. If the paint is diluted too much, it gets a wash-like consistency. All of this also depends on the primer. If you did not apply the right amount of undercoat, the paint might run even though it is the right consistency.

What you should remember is this: **The paint should be thinned so it behaves as you want it to.**

What does this mean in practice? If you want the paint to pool in the corners, then it is good if it pools in the corners. If you are trying to make a good base-coat, then pooling is not to be desired. There is no magic formula. Forget about "1 drop of water to 2 drops of paint" stuff. The formula depends on too many variables to have a formula that works for every colour, but they can work as a starting point, before adding more paint or thinner till its right. Just remember: look at your paint and feel your paint. Is it behaving and applying in accordance with the method you are currently doing? Then it is probably the right consistency.

There are several things you can modify when you are trying to thin down your paint. One thing is the liquid you use for paint dilution. The other one being the technique you use for thinning your paint.

The most common liquid to thin with is water. Most people use it, since it is easy to get and to handle. But be careful: If your tap water is too hard – meaning it contains a lot of minerals – it might affect your colors and how the paint behaves. In that case, you are better off with just buying distilled water or bottled water from the supermarket. The distilled water will be better for the paint as it has less contaminants.

"What you should remember is this: The paint should be thinned so it behaves as you want it to"

Because water can a be bit of a pain to work with, there are other liquids you can use for thinning that might work even better. Water has the disadvantage that it evaporates quickly, which leads to a change in the consistency of your paint, this may not seem important, but can have a noticeable effect on your finish. The surface tension of the liquid you use in diluting your paint also has a say in how the paint behaves afterwards.

Instead of water, you can use thinners, such as Tamiya X20a thinner, or Mr. Colour thinner, or medium. Medium is often made from the same material that the paint is made from. It keeps the body of the paint, so it has the same colour and properties, only thinner.

Just keep in mind to never ever use alcohol unless its a hybrid paint (Such as Tamiya or Mr. Colour), this does not dilute water based acrylic paint, but will dissolve it completely, ask me how I know!

One thick coat is not the way to do it

I recommend that you apply several thin layers of paint onto your model instead of just one thick, blotchy layer. While this method might take some more time to let each layer dry before applying a new one, it comes with several advantages.

Keep the details visible: A single big layer just covers all the details in the model. Thin layers do not do that, so they help you preserve the details on your model.

it might not be a good idea to put 50+ coats of really thin paint on your miniature. It might look awesome, but that is just too much work. Stick to about two to five layers, depending on your paint and the method you are going for. A nicely thinned layer of acrylic paint is semi-transparent, so the color should not be opaque until you applied several layers. Keep in mind that each layers needs to dry before applying the next.

"Apply several thin layers of paint onto your model instead of just one thick, blotchy layer"

You will only learn to thin your paints by doing it

It is important that you learn to get a feeling for the right dilution. Does the paint feel nice and is easy to apply? That seems like a good consistency! Does it clump or run? When it clumps, and you have to stretch and work hard to move it around, the paint is too thick. When it runs, the paint is too thin or you got too much water/thinner in your paint mix. If you can use easy, smooth brush strokes to paint with, the paint mix is about right.

If you have some smooth plastic or a spare model, just try some things out to get the hang of it. Just paint a line with undiluted paint. Then use some medium or water to thin it down a bit. Now you can thin it down more and more to get to the point where it is too thin. Let your paint dry and look at the results: The colour is barely visible – too thin. The first coat already covers completely – too thick.

You should try the above mentioned method with several colours and paints of several brands. The latter one applies of course only when you actually use different brands of paint for colouring. Different kinds of acrylics actually need different thinning. Citadel paint is often rather thick, while Army Painter or Vallejo colors are already thinner. Vallejo air is specifically designed to be thin enough to airbrush without any more dilution, but I've found its about the right consistency for brush painting, but does need thinning before spraying. Tamiya, AK Interactive 3rd gen and Mr. Colour paints while great for airbrushing, are difficult to paint with unless VERY thin, and thinning to this thickness will result in lots of layers in order to get a consistent coat, therefore, it is recommended to only use these for airbrushing.

Thinning Acrylic Paint For Airbrushing

A lot of things come into play when finding just the right consistency of the airbrush paint you are using to atomize correctly. The type of airbrush you are using, needle and fluid nozzle size and the air pressure you are using all come into play. The amount of reduction also depends on the size of the nozzle in your airbrush; 0.5 mm nozzle will spray much thicker paint than a 0.2 providing the correct air pressure is being used. Over reducing some paints might have an adverse effect and the paints might not adhere as well. The key to this is experimenting to find what reduction works best for the paints you use and your airbrush.

Airbrush thinner is for thinning paints while paint extenders that the paint companies make, more often than not, do not make the color thinner but do make it more transparent. On the other hand, Flow improver is medium used to improve flow of paint and it helps to avoid tip drying. You can add couple of drops of flow improver in the airbrush and it will *Ahem* improve flow.

As previously mentioned, the constancy needs to be roughly that of skimmed milk. I usually start with 3 parts paint, to 2 parts thinner and go from there, adding paint or thinner as necessary, till the right consistency is achieved.

At a PSI of around about 15, the paint should atomise easily and clearly if it is correctly thinned, with minimal overspray at around about 1-2 inches. Nozzle clogging and tip dry should be minimal if the paint is correctly thinned, so either of these is an indicator you may either need to thin it a little more, or turn up the air pressure, but be careful when using the latter, it may cause spider-webbing if the paint is quite thin. This happens when the paint is too wet and the air pressure too high, where as overspray happens if the paint is too thick and the air pressure too high. Overspray is where the edges become spattered. Both of these can be see in the picture below, as well as an example of a perfectly thinned airbrush with the right air pressure.

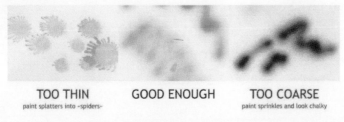

TOO THIN GOOD ENOUGH TOO COARSE
paint splatters into »spiders« paint sprinkles and look chalky

Chapter 6

How to apply
Decals

I f, like me, you have great difficulty with decals (I loathe the things) then this, is most definitely the article for you.

Here we have a few hints and tips on how the get the best out of your decals, and how to make your kit look great using them.

Applying Waterslide decals

For this tutorial, I'm going to assume that you've already gloss coated your model (more about why this is important later) Cut out decal, that you want to stick to the model, from the sheet. Take care not to cut into the edges of the decal or into the other labels. Put the decal with tweezers in tepid water for about 10 seconds. The paper will start to saturate with water and it will curl a little. This can be remedied by turning the paper over. Don't leave the decal in the water too long though, as it may separate itself from the backing paper, and then you'll have difficulties with pulling it out from the water without it curling and sticking to itself.After 30 or so seconds, pull the decal from the water, put it on the table, We will use a wet cotton bud to try to push the decal, and if it moves, it can be applied on the model.

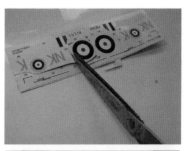

First, moisten the surface of model with decal softener, (i use Microset by Microscale industries, but if you don't have decal softener, or aren't confident using it, then using water will be fine), where the decal will be placed. If the surface is dry, the decal will stick to the model, and while re-floating it might be possible, it will be a lot harder to move it into its exact position.

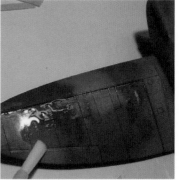

Hold the paper with the decal on, and transfer the decal onto the model. Don't use a sharp tool to move the decal, you'll likely damage it, as I have before when using my AK fine tweezers.

Once you have slid the decal into place, wipe the surface water away, with either a brush or a cotton bud, and press down firmly on the decal. This will help the decal sink into any recesses and look less like a decal, and more like its sprayed on.

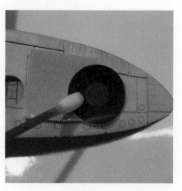

Once this is done, cover it with a coat of decal setter, this will melt the decal to the surface of the model and help make it look painted on.

"The surface of the model is not actually flat, well, at least not a micro level anyway, but this is beyond the view of the human eye"

Gloss coating, and why its important.

"So whats with the gloss coat?" I hear you say. Well... we gloss the surface so air doesn't get trapped underneath the decal and cause silvering.

The surface of the model is not actually flat, well, at least not a micro level anyway, but this is beyond the view of the human eye. Imagine the shape of a certain Swiss chocolate that is modelled to represent the alps. If you can imagine trying to lay a flat decal on top of that, then you begin to see how air gets trapped beneath and causes silvering.

The silvering is the reflection of light onto the air bubble, similar to how a bubble of air in water looks when it rises to the surface. To combat this, we put a gloss layer down onto the model kit. This evens out the surface, and whilst not actually flat, its less spiky, and can be considered more wavy, thus, it doesn't allow air to be trapped underneath, and allows the decals to be put down flatly.

there are ways to rectify silvering, but its not ideal and prevention is much better than a cure.

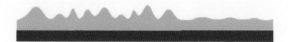

The diagram above shows the untreated surface on the left, and the gloss coated surface on the right.

It demonstrates perfectly why silvering occurs, and why gloss coating is an essential step in stopping silvering from occurring.

Aside from levelling the surface out, it also provides a 'save point' for all your previous work, on the off chance you may make a mistake with the weathering.

What to do If you get silvering

There are many ways of sorting silvering out, they best way, of course, is not to get it in the first place, but on the off-chance you do get it, then, at least know, it can be rectified with little problem.

Cutting the decal film off

This is quite a labour intensive solution, but it may be the only chance to rectify silvering if the decal has a large area of film to try to de-silver, like the decal pictured. Take a new blade, on a craft knife, and trace around the decal film to be removed, slowly peel away the cut decal film. When finished, re-apply a coat of decal setter and smooth down with a cotton bud.

Piercing the film

This is an easier, but less predictable or controllable way of fixing silvering. Simply pierce small holes in the decal, then apply a softener and setting solution to try to draw the decal into the surface. This may need repeating many times and is dependent on many things such as: how long the decal has been applied, how old the decal film is etc.

"This may need repeating many times and is dependent on many things such as: how long the decal has been applied, how old the decal film is etc. "

Setters and Softening Solutions

In terms of modelling tools, setter and softening solutions are a relatively new addition to the modellers toolbox, but there are some very aggressive, strong solutions out there. Because of this, it may just well be possible to fix some silvering by just applying these to the decals. Personally, i always try this and leave it overnight before i attempt any other step, as it may just save wasting time on a solution that takes longer.

Chapter 7

Basic Weathering Techniques

Weathering, refers to a number of techniques that are intended to make a model appear more realistic by simulating the effects of the elements on the subject.
Although not entirely correct, the term is often also used to describe Similar techniques intended to enhance realism by compensating differences in lighting and viewing between the model and actual subject, like enhancing shades or highlights on the model's surface.

Weathering has developed tremendously over the recent years, especially in the area of armour modelling. There is now a whole variety of techniques to simulate dirt, fading, spills, paint wear and tear, rusting, etc. Most of the time, these techniques are used in combination rather than alone, to simulate the diversity of the natural ageing and wear processes.

Far from being a mere last step in a modelling project, weathering now compels the modeller to take time and effort, often on par, or exceeding time-wise, with construction and painting. In my view, this is positive, because not only does weathering leave plenty of room for creativity and artistic license, and as such can be one of the most enjoyable parts of modelling, but its means we, as modellers, get to try new techniques and develop as artists.

The weathering stage goes after the decals, so what you will have to (except for assembling the model) apply the basic paint scheme, decals and gloss coat first.

With the paint and markings and gloss varnish applied to the entire model, it will have a shiny surface that will help with the weathering process. A matt coat is OK for weathering, but gloss will draw the wash/oil paint into the recesses better, will stop the oil paint from staining, and will help you to clean up the wash/oils paint better. However, if you are looking for a really dirty finish, that is stained, muddy and filthy, then a matt coat might be a better choice of finish for this process.

Filters

Not to be confused with a traditional wash, the technique of applying
filters has been pioneered by Miguel "Mig" Jimenez and is explained in his
article on the MIG Ammo web site, so I will only explain it in short here.

A "filter" is added by an swift application of a single, heavily diluted colour
over the entire model.

A good filter will increase harmony between the various colours of the camouflage and reduce contrast
between them. Think of it like a blend layer, to bring all the different colours together.

"A good filter will increase harmony between the various colours of the
camouflage and reduce contrast between them. Think of it like a blend layer,
to bring all the different colours together "

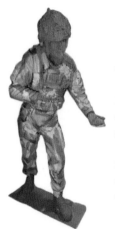

This will ensure a more uniform look to the paint
work, as seen on the figure.

Left, without a filter. The colours can clearly be
distinguished from one another, and look too
stark in contrast.

Right, with a filter. The colours are brought
together more, and are less distinguishable, but
still visibly different.

Usually, when using a filter, it be a slightly different colour to the base colour, IE, if filtering a black model,
then the filter will be grey, if filtering a red or orange kit, the filter will be yellow, especially if using a filter
to add a faded look. However, there are filters specifically designed for certain thing, IE, for filtering a blue
model, or a olive green model, and sometimes, these will consist of more than one filter. It is always worth
looking to see if there is a set on the market already that will cover the effects you are looking for.

Whilst most filters are enamel, a filter can also be achieved with a very highly diluted acrylic paint or a pre
made acrylic filter. These are not as popular as the enamel filters though, as they dry quickly, and cannot
be re-activated and re-worked, like the enamel filters can. They do leave very good results if you can get
used to working quickly, or with keep them wet while you work. A very good example of a modeller who
uses these very well, is Thomas, from Laser creation world. You can find examples of his work on
YouTube, and I highly recommend him.

Now the painting is done, its time to give it a gloss coat, to prepare for decalling.

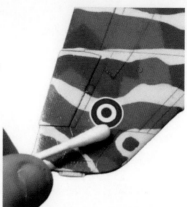

It is recommended that you do this before putting the decals on, but, like the priming, there are some modellers who I respect greatly who don't, so this is entirely up to you, but I will say this: as explained previously, a gloss coat does help prevent silvering by levelling the surface and whilst a flat surface is entirely possible to achieve with an airbrush, its unlikely as a new modeller, that you will be able to get a flat a surface as you will need without a gloss coat.

But don't worry, this can be applied with a brush!

It is pretty hard to get a nice flat coat without using a flat brush, it can be done, or so I have been informed, but I have never managed it myself.

Whether you need to thin the gloss coat or not, depends on which gloss coat you use, but as a rule of thumb, for brush painting, its a good idea. Its also a good idea for airbrushing too by the way!

a gloss coat needs to be thinner than it is in the jar, but thicker than paint, as there needs to be a coat thick enough to cover the bumps on the surface of the model, but not too thick it will cover all the details and be gloopy. Make sure you clean the surface thoroughly, as anything left on the surface, will be there forever!

Once the gloss has been mixed, apply it like the primer, in sections, letting it dry for a few minutes in between, and repeat until the whole model is done. It will take around 24 hours for the gloss to cure fully, so make sure you allow time for this before adding decals, as water can make uncured gloss coat, really manky (depending on the type of gloss coat)

The gloss coat should self level during the process of curing if it has been thinned correctly, again, there is no set formula for this because of the varied types of gloss coats available, but one thing you do not want to do, is put an enamel varnish over an acrylic paint, or vice a versa. **THIS. WILL. END. BADLY**. No if's, no buts, it *WILL* be bad, and it *WILL* be unsavable without stripping the entire model and start again. You have been warned!

An easier option for the beginner, is the gloss coat spray cans, but this will affect the finish of the clear parts if you spray them onto it without masking them first. Ask me how I know! Rattle cans tend to be a lot more even than brushing it, and will take a lot less getting used to as a beginner and requires no thinning etc.

If there are any problems with the finish, this can be sanded using a high grit sandpaper, till smooth, and touched up where necessary. Repeat until happy with the finish.

Scratches and chipping

Now is the time to add wear and tear. Painted objects exposed to
handling, walking etc. will inevitably develop large and small scratches
and scuff marks which, in time and greater numbers, will alter the
overall appearance of the surface from "uniform" to "worn".

There are a few different techniques to simulate scratches. I found that
a simple but, very effective technique, is to use chipping fluid or
hairspray. To achieve this effect, you will need to cover the primed
model in either water based hairspray, or chipping fluid.

They both essentially do the same job, but hairspray is often much cheaper. when the water is applied to
the paint, it soaks through and reactivates the hairspray/chipping fluid, removing the paint layered above
it, leaving the primer/colour underneath to show through, thus creating a realistic chipping effect.

Apply the final coat of paint and wait till dried. However, don't wait too long, as the longer you wait, the
harder it will be to chip the paint. Begin by brushing or spraying the model over with water, then, dipping
your a stiff bristled brush in water, begin to rub away the patches of paint you wish to remove. With a
medium amount of pressure, you should to be able to achieve realistic, and most importantly, in scale
results. Finer chips can be made with a toothpick or an old airbrush needle.

To give the chips more depth, you can apply a dark grey/steel colour on top. For this, a fine brush is
needed. Dark grey is the ideal colour for well worn vehicles, or a metallic colour for a newly chipped
vehicle. To apply this, lightly dip the brush into the colour you've chosen, and holding the brush close to
the top (this is essential so the touch of the brush is not too heavy, which will cause the result to look out
of scale) and draw it lightly over the spot you have just chipped.

As a general rule of thumb, less is more. You can
always top it up if you put on too little, but it may
take a bit of work to clean if up if you put on too
much.

It may take a little practice to get the weight right,
so don't be afraid to practice on a bit of card
before trying it on the model.

"It may take a little practice to get the weight right, so don't be afraid to
practice on a bit of card before trying it on the model."

Panel lining

Panel lining is one of the most basic things you can do for your model kit that's relatively easy to do and gives awesome results.

Gundam Markers, Real Touch Markers, and Mechanical Pencils.

Gundam Markers are available in your favorite hobby shops. Basically, it's just like using a pen and paper. In this case, you line along the panel lines so it's relatively easy. For excess lines, you can easily erase them by simply using your finger or eraser and you can also use a cotton bud dipped in alcohol. You can also thin the lines down by doing this.

What you should be wary of is that, if you don't gloss coat the model first, and the ink is still wet when you topcoat over the lines, they might bleed out. Sometimes, even the dried ones still bleed, it really depends on the topcoat and the thickness of the line. So if top-coating, make sure you do it by mists and not a single heavy coat. Mechanical pencils do not have this issue.

"Modelling is very much a hobby where everyone will have their favorite, and only trial and error will find out which you prefer."

Panel Washes

A once hard technique that involved mixing paints, Tamiya, and several other companies decided to sell pre-mixed washes that are meant to be used for panel lines. This has made it a lot easier for both beginners and advanced modeller's to do their panel washing. MIG Ammo has a variety of washes that isn't just meant for creases, panel lines and such, but also for the paint job as well. It adds streaks, dirt, rust, rain marks, moss and the like.

This is really easy to do, just touch the edge of the panel line with the brush, and capillary action will move the fluid along the panel line. Carry on touching the panel line where the fluid ends until the model is done.

This may need cleaning up, to do this, you will need a brush or a cotton bud, and enamel thinner. To do this, simply wipe along the area you wish to clean.

It is also possible to create dirty marks by blending the panel liner, again using the enamel thinner, but instead of wiping it away, softly blend it in to create dirty marks.

Again, its a good idea to gloss coat before putting panel wash. It doesn't just help with cleaning up, it also improves the capillary action. Also, enamel thinner, lighter fluid or any oil based thinners are generally bad for painted plastic, and whilst it wont destroy it, it can weaken the plastic and make it easier to break.

The main reason why panel washes are made of enamel is because it's safe to use over an acrylic or lacquer layer.

If you have painted your kit with enamel paint and didn't cover it up using an acrylic lacquer topcoat, then you'll end up destroying your paint job. Using acrylic as a wash isn't really recommended because it dries quickly. Lacquer on the other hand is even more quick drying and will destroy your paint job, more so as a wash.

"Adding panel lines is not meant to be REALISTIC. In fact, it's not realistic at all. Aircraft don't have big black lines on them, but what it does do, is create visual interest."

Weathering Powders/Pastels

Dust is an ever-present companion of military vehicles. Just how much dust to apply is a matter of personal preference, but don't be afraid, real tanks are covered in much more dust and dried mud than you likely think.

Unlike filters, dust calls for a dry painting technique for greater realism. You can use powder from dry pastel chalks or dry pigment powder. Both can be readily obtained from well-stocked hobby shops, and pretty much use the same technique, that of loading the brush and applying liberally over the model. To keep this in place, apply acrylic thinner over the top of it, when it dries, it will act as a fixative. To achieve wet effects, apply enamel wash on top of it, not only will this give a wet effects, as it will dry glossy, but it will give some lowlights and contrast to your model.

Chapter 8

Building Your
first model

A great first step is to go to a local hobby shop (or, if you don't have one near you, browse the model kit section of your favourite online shop.

The best way to get started is to first determine what subject you want to build. Next, you want to determine what skill level is best for you. Finally, you want to choose the scale (size) of the kit, and ultimately the specific kit itself.

To begin with, it is important to follow the instructions step by step, and that the various parts are cleaned up before gluing. Failure to do so could result in a bad fit, and parts being raised where they shouldn't be or parts not sitting correctly or at all.

To do this, you will need to remove the part with your sprue cutters or knife, as close to the body of the kit as possible. Once this has been done, sand the remaining lump left from removal from the sprue till its flush. It is very rare to remove a part from the sprue without leaving small lumps that need removing. Sandpaper is ideal for this.

Once these have been removed, dry fitting the parts is a MUST. Do not underestimate the importance of dry fitting. it ensures all the parts fit properly before you glue them, other wise, you run the risk of non fitting parts or trying to glue them when they don't fit at all. This is far from ideal if, like me, you are somewhat of a perfectionist.

There is an old saying "Measure twice, cut once" well, this is exactly the same with model kits, except with dry fitting. Dry fit twice, fit once.

You can either do all of the parts together, or cut them off and clean them up as you go along, every modeller does it a different way, but, if you are going to do it all at once, it might be beneficial to label each part with the number, so you can still follow instructions without any problems, after all, the idea of the instructions is to help you build it in a way that gives you the best possible experience and makes things as easy as possible.

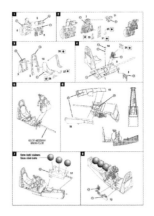

Following the instructions, start gluing the pieces together in sequence, in the case of an aircraft, it usually starts with the cockpit, which will require painting first, as it becomes very difficult to do so after the fuselage sides are closed up.

It is worth taking your time and doing it slowly, remember, not only are you building this for fun, but you are learning new skills, and rushing through it might get you there quicker, but it will make the chances of making avoidable mistakes much higher.

> "After all, the idea of the instructions is to help you build it in a way that gives you the best possible experience and makes things as easy as possible"

It is likely, that no matter how good the kit it, there will be some gaps that need filling, if you have filler, then read on, if not, skip to the next section. There are many ways to fill a gap in modelling, but as a starter, I would suggest using water soluble putty, AV Vallejo Putty is a great and easy putty to use for beginners, as a matter of fact, its my favourite filler and I cant even remember when I was a beginner!

Taking a small amount of putty onto a tooth pick/kebab stick or something with a tapered end, and smother the putty into the gap liberally, till the gap is filled. Repeat on all gaps. with a wet cotton bud, wipe along the gap to remove excess putty, whilst leaving the gap filled. This should leave the gap even, but on the off chance it doesn't, refill with putty and remove with another wet cotton bud.

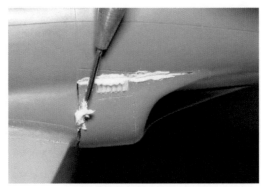

Once the putty has dried (it usually takes couple of hours to be touch dry, and about 24 hours to be fully cured), rub lightly with a high grade sand paper to remove any residual putty from the surfaces of the model. This will uncover anything that is possibly covered by the putty, and smooth it enough to be close enough to the surface of the model so it wont be an issue when painting, and also wont leave clumpy bits which will ruin the look when finished.

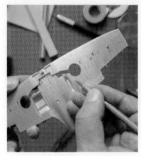

Now is the time to paint the model. In the previous section, we spoke about paint thinning, its now time to put that into practice.

You may want to use a coat of primer before you paint, I highly recommend it, but I do know other modellers whom I highly respect who don't prime their models, If you don't plan to do this, then skip forward.

Taking a flat or large round brush, brush the primer as smoothly as possible onto the model one part at a time, making sure to be careful not to touch the wet parts. once the model is all done, leave for 24 hours to cure fully.

Once the primer is dry, check the surface of the model for lumps of paint, and if you find any, use a high grit sandpaper to remove these lumps and re-prime. repeat until you are happy with the finish.

Once the primer surface is completely flat and you're happy to start painting, sketch the camouflage onto the primer, lightly with a pencil. It is important to do this lightly, as a sharp pencil pressed heavily, WILL take off primer. Ask me how I know! When working with different colours, I mark each camouflage with the colour they are to be painted, IE B for brown, G for grey, GR for green etc. When painted the pencil marks will be covered, so there is no need to worry about anything being seen later on.

Starting with your first colour, mark the outlines of the camouflage, then fill it. If the paint is thinned correctly, then it will look very thin and will need at least 3 layers, if you find its too thick, don't worry! you can still save it by wetting your brush and thinning the paint on the surface of the model. Remember to thin the paint in the palette a bit more before continuing. Continue painting the model until all of this colour is finished and clean your brush.

After cleaning your brush, proceed to paint the other colour, again, starting with the outline, and filling it in. Repeat until all the paint is done, and re-clean the brush. By this time, the first coat of paint should be dry enough to add a next coat. Build up the layers of paint until you are happy with the opacity of the coats.

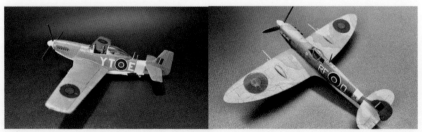

Left: An example of brush painting using paint that was incorrectly thinned
Right: An example of brush painting with correctly thinned paint.

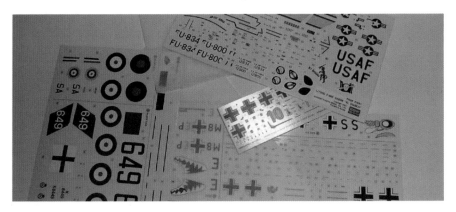

Next step is the decals.

There is a full break down of how to apply decals on page 20 using decals softener and decal setting fluid, but for this, I will give a brief run down using just warm water.

After cutting out the decals which you wish to apply, soak them (individually, as soaking them all at once may lead them to break up in the water) in warm water for about 30 seconds or so, depending on the make of the decals, or until they detach from the backing paper.

Wet the surface of the model kit with a wet brush, in the area the decal is about to be placed, this is so the decal can be moved into place if necessary or re-floated. apply the decal to the surface of the model and adjust as necessary, and move into place.

Remove all the excess water with a cotton bud, and press down and roll about the decal to press it into the surface.

Repeat with all of the decals that you wish to put onto the model.

Tips: Be careful with long, thin decals, as these are quite easy to break.
 Using sharp tipped tweezers can tear the backing paper the decal is printed on.
 Decals with clear carrier film can be cut away to look better, but be careful, this will make the decal fragile.
 Whilst not strictly necessary, decal softener and setter will make the decal look more realistic.

"Wet the surface of the model kit with a wet brush, in the area the decal is about to be placed, this is so the decal can be moved into place if necessary or re-floated. apply the decal to the surface of the model and adjust as necessary, and move into place"

The next step is optional, but for the benefit of this tutorial, we will assume you are going to complete this step. Weathering. If you don't plan on adding any weathering at this stage, please skip to the next section.

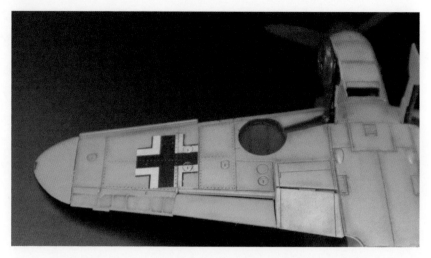

This BF109 F4 has been weathered using oil paints to make the panel lines stand out

We discussed weathering in the previous chapter, and there are plenty of ways to make your model stand out by weathering, but these mostly require extra products such as panel line fluid, pigments or oil paints. Most of these effects are relatively cheap, and easy to learn to use, so are beginner friendly, such as panel line fluid and pigments. Pigments can be used to simulate dust, and when added to a little thinners, can be used to simulate mud on tires, splashes on tanks, cars etc, smears on windscreens as well as many other practical effects on many different model types.

Once you are happy with the weathering of your choice, we will move on to the next, and final step, which is also optional, but highly recommended.

The panel lines on this Mosquito really stand out thanks to Tamiya panel line accent colour

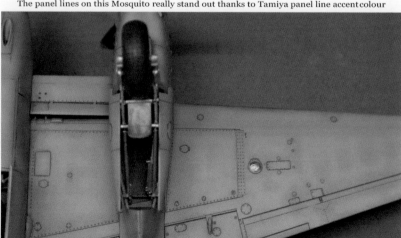

Matt coats work in a similar way to the gloss coat, but rather than making the surface even, the idea here is to seal in the paint, decals and weathering, and protect the model from harm, as well as to give it a nice, flat finish.

Of course, this doesn't have to be done, but its advisable, after all the effort put into the model you've made, to take one last step to ensure it lasts to be enjoyed.

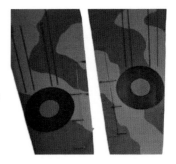

"After all, the idea of the instructions is to help you build it in a way that gives you the best possible experience and makes things as easy as possible"

The matt coat, sometimes known as a flat coat, is applied in very much the same way as the gloss coat, either by brush or by rattle can.

Again, if applied by brush, it may need to be thinned depending on which matt coat you're using, and again, only experimenting with it will find out what works properly as again, there is no set formula, and using rattle cans again will require clear part masking, as the gloss and matt coats have a fogging effect on clear parts such as canopies, headlights, windows etc.

Once this is done, sit back and admire your very first model kit, for you have now joined the ranks of many others and may now consider yourself a scale modeller! Its good to remember that this is your very first build, and as such, being able to take a step back and seeing what you did well, and what could be improved for next time, is a very valuable thing to be able to do. This goes back to the reflection section of the build plan, as mentioned in chapter 2.

Don't be too critical about yourself, but try to be pragmatic. Ask others for constructive feedback on both good points and bad points, where you did well, where you could do better, and set yourself goals for the next build.

If you feel you need practice in a particular area, try to plan a build that will necessitate using that skill in the next few builds, or if you want to try something new, then pick an appropriate kit for that skill.

Lastly of all, don't compare yourself to others, the fun of modelling is not in outdoing others, but in developing ourselves and growing as modellers. Remember, we build to completion, not perfection.

Epílogue

Final words from the author

By now, you should have managed to build your very first model, using some of the tips and tricks in this book.

If not, then hopefully you have learned enough to be able to make things much easier than it would have been before reading this book. Some of the skills in this book, will form the basis of more intermediate or advanced techniques, but I'll go through those in the next books.

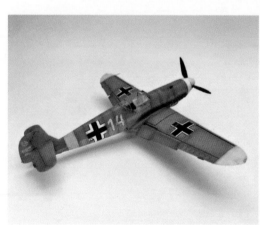

With a bit of luck, you will now have a love of making models, or even better, a sincere scale model habit. It has always been a love of mine, and introducing others to the joy of it is just as satisfying as building models themselves.

Its the one hobby that makes no difference if you're old or young, male or female, able bodied or disabled, and it brings people of all sorts together with one common interest. Currently, the scale model community online, is one of the friendliest and helpful I've ever been part of, and I highly recommend it to you as well.

If you are more of a visual learner, and have found these books to not match your learning style, then please, feel free to visit my YouTube channel, Kits and Bits Scale Modelling or @KABmodels, where there are plenty of tutorial videos which will walk you through some of these skills visually, as well as plenty of build videos, live streams, shorts, giveaways and much, much more! Welcome to the world of scale modelling!

Sláinte!

Tam - Christmas 2023

Printed in Great Britain
by Amazon